Hello,

We hope you enjoy getting creative with our hunks. They're ready and waiting!

It would be great to see your artwork, send them to us via: www.facebook.com/colorthathunk

OPOC MEDIA
OPOC Media is a Limited Liability Company registered in The United Kingdom with number 10331933

First published 2016
Copyright © OPOC Media, 2016
Volume 1.1

ISBN-13: 978-1540479143
ISBN-10: 1540479145

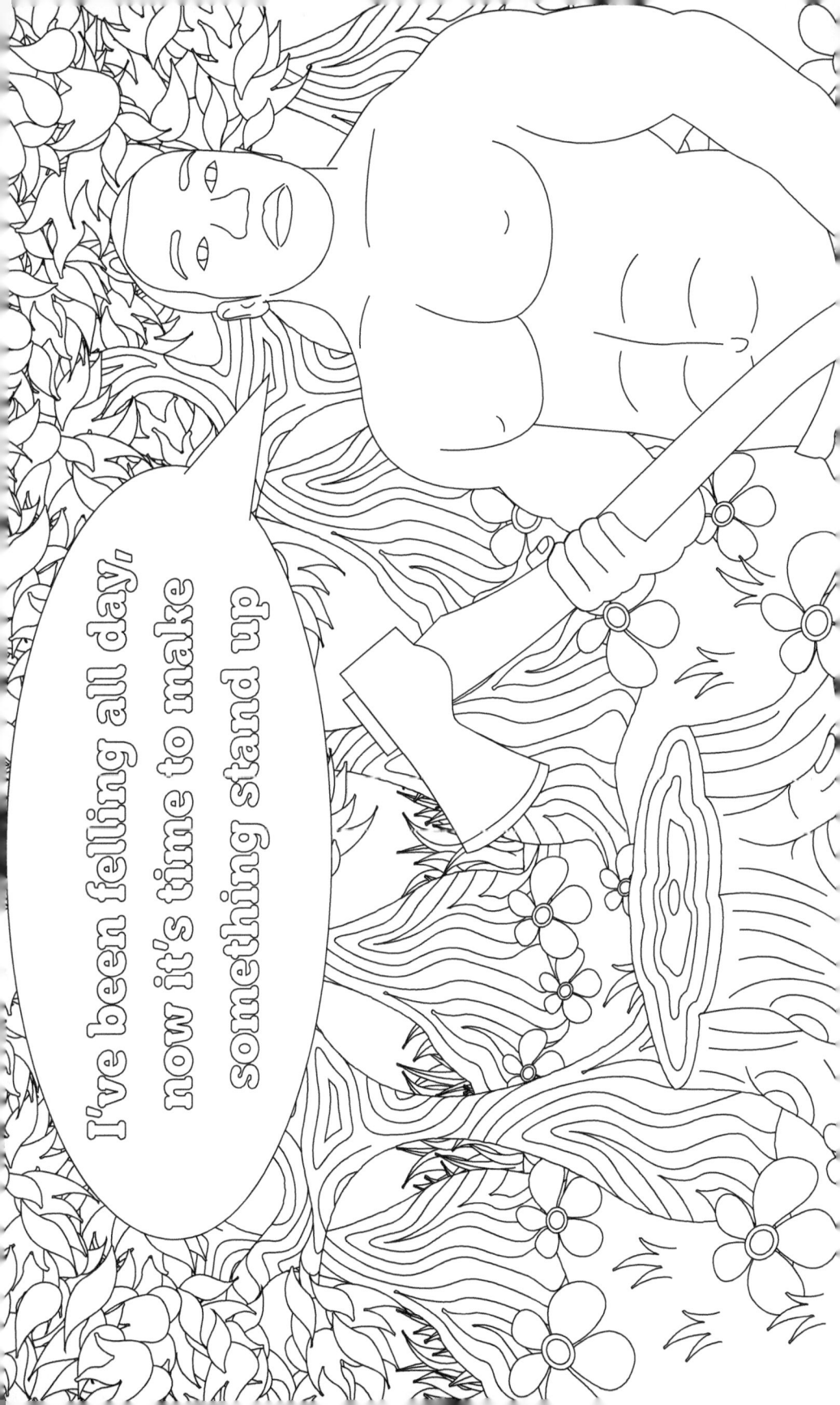

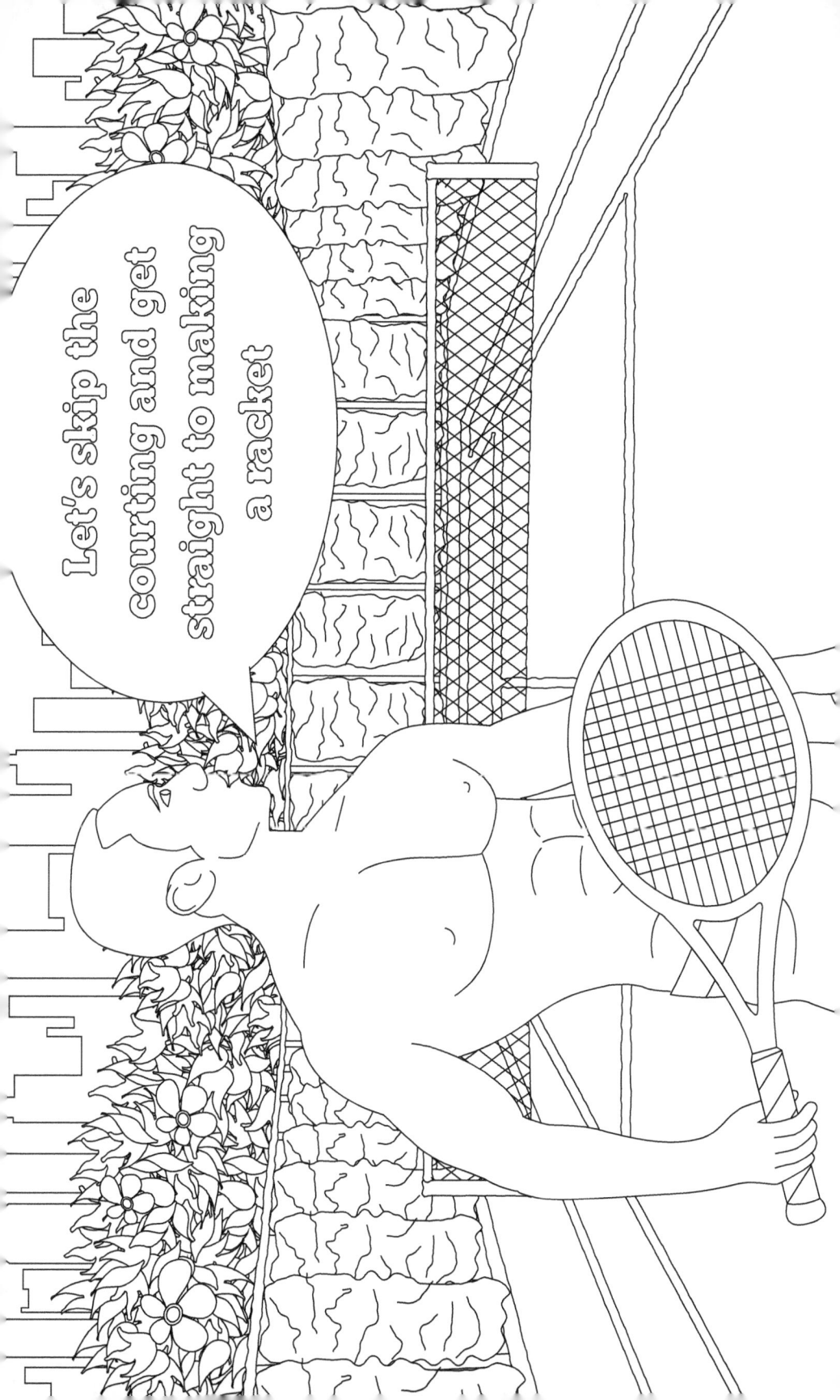

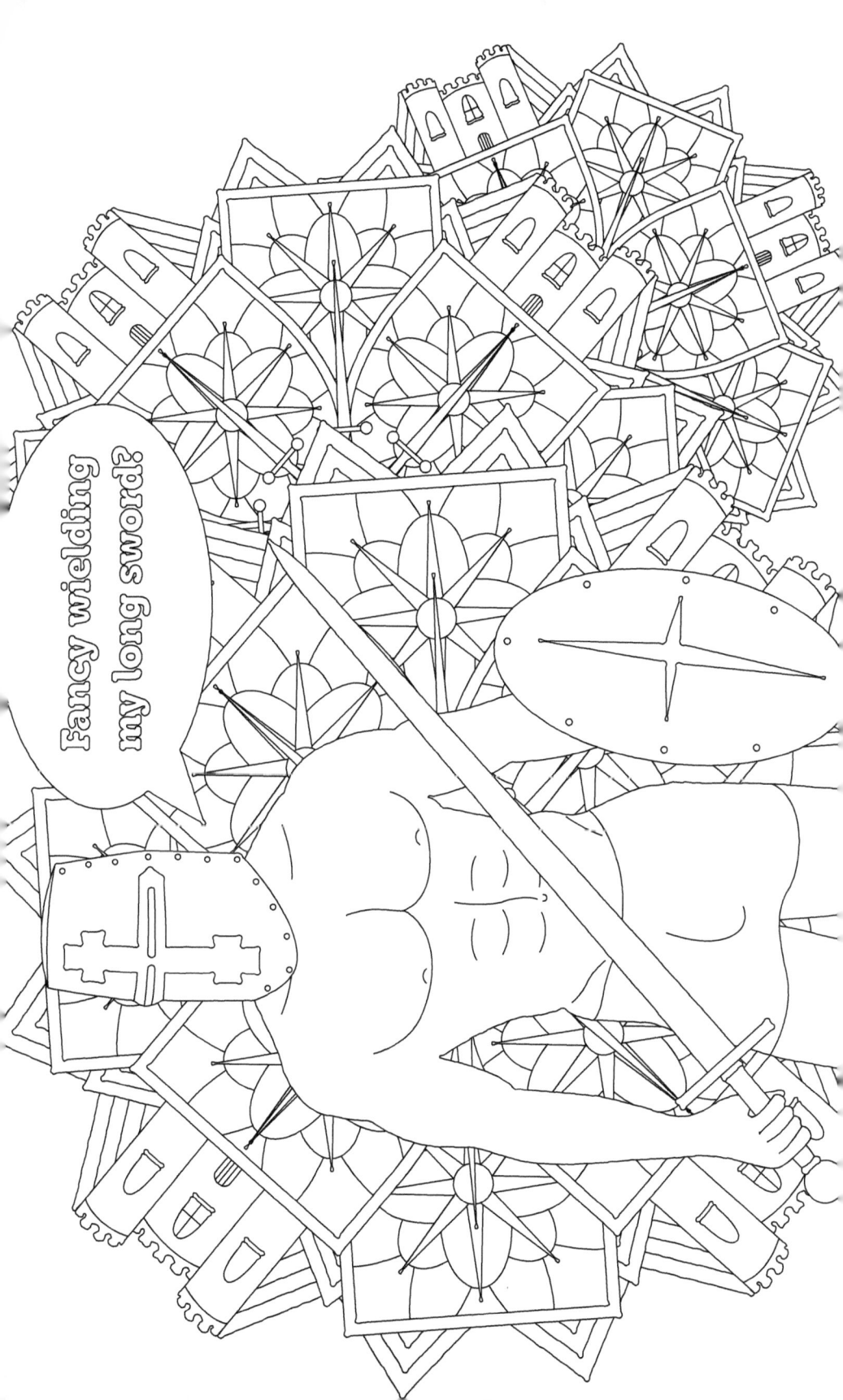

www.ingramcontent.com/pod-product-compliance
Lightning Source LLC
Chambersburg PA
CBHW061450180526
45170CB00004B/1645